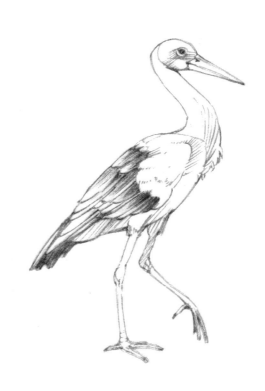

For the genial and lovable Muriel Z

DRAW 50
BIRDS

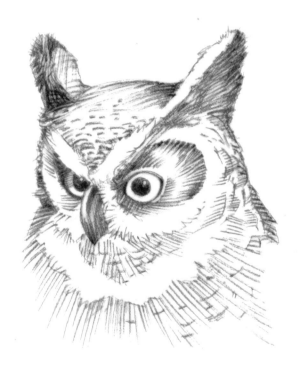

DRAW 50
BIRDS

LEE J. AMES
with TONY D'ADAMO

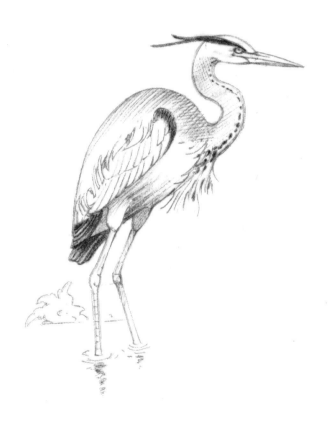

KING*f*ISHER

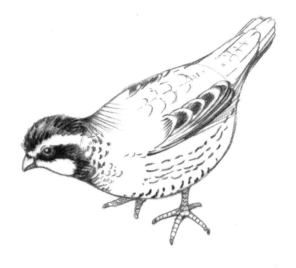

KINGFISHER
An imprint of Kingfisher Publications Plc
New Penderel House, 283-288 High Holborn
London WC1V 7HZ

First published in Great Britain in 1998
by Kingfisher Publications Plc
Published by arrangement with Doubleday,
a division of Bantam Doubleday Dell Publishing Group, Inc.

10 9 8 7 6 5 4 3 2

Copyright © Lee J. Ames and Murray D. Zak

A CIP CATALOGUE RECORD FOR THIS BOOK IS AVAILABLE FROM THE
BRITISH LIBRARY

ISBN 0 7534 0269 6

Phototypset by Rowland Phototypsetting Limited,
Bury St Edmunds, Suffolk
Printed in Spain

AUTHOR'S NOTE

I have known, respected and admired my friend Tony
D'Adamo for more than twenty years. We have often
worked together. He is a wonderful artist, cartoonist,
illustrator and human being, and together we are fellow
members of the Berndt Toast Gang, a major branch of
the National Cartoonists' Society.

Tony started his professional career as a comic book
artist with Fiction House Publications and worked with
that organization until he was called into the armed
forces. After his period in the military, he freelanced as
an artist for pulp magazines, illustrated about thirty
children's books, and created story-boards, film strips,
film slides, and advertising art.

For over fifteen years he was the staff illustrator for
EDL, an educational book publishing company based in
Huntington, New York. His drawings, accordingly,
appeared in publications for grade school children and in
high school and college-level books.

In January 1979, Tony joined the staff of a New York
newspaper, *Newsday*, and his artwork has been
appearing there and glorifying its pages ever since. This
includes a regular panel cartoon feature he reserches
and illustrates that focuses on obscure laws and
ordinances, entitled "Laws Long Ago".

Tony and his wife and daughter make their home in Fort
Salonga, Northport, on Long Island.

TO THE READER

When you start working, use clean white bond paper or drawing paper and a pencil with moderately soft lead (HB or No.2). Keep a kneaded rubber handy (available at art supply stores). Choose the bird you want to draw. Try to imagine the finished drawing on the drawing area. Then visualize the first steps so that the finished picture will nicely fill the page—not too large, not too small. Now, very lightly and very carefully, sketch out the first step. (These first steps are indicated in colour for clarity. You can use a coloured pencil crayon here if you prefer, or a normal pencil.) Next, very lightly and carefully, add the second step, the third step, and so on. As you go along, study not only the lines but the spaces between the lines. Remember, the first steps must be sketched with the greatest care. A mistake here could ruin your final drawing.

As you work, it's a good idea, from time to time, to hold a mirror to your sketch. The image in the mirror frequently shows distortion you might not recognize otherwise.

In the book you will notice that the new step additions (in colour) are printed darker so they can be clearly identified. But be sure to keep all of your construction steps very light. Here's where the kneaded rubber can be useful. You can lighten a pencil stroke that is too dark by pressing on it with the rubber.

Continued over page

When you've completed all the light steps, and when you're sure you have everything the way you want it, finish you drawing with firm, strong pencil strokes. If you like, you can go over this with Indian ink (applied with a fine brush or pen) or a permanent fine-tipped ballpoint pen or a felt-tipped marker. When thoroughly dry, you can then rub the kneaded rubber over the entire surface to clean out all the underlying pencil marks.

Remember, if your first attempts at drawing do not turn out the way you'd like, it's important to *keep trying*. Your efforts will eventually pay off and you'll be pleased and surprised at what you can accomplish. I sincerely hope, as you follow our techniques, that your skills will improve. Following the way Tony and I work, and then exercising your thinking tools, can open the door to your own creativity. We hope you will enjoy drawing our feathered friends.

Lee J. Ames

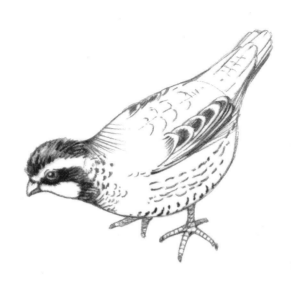

*Have fun with
your drawings...*

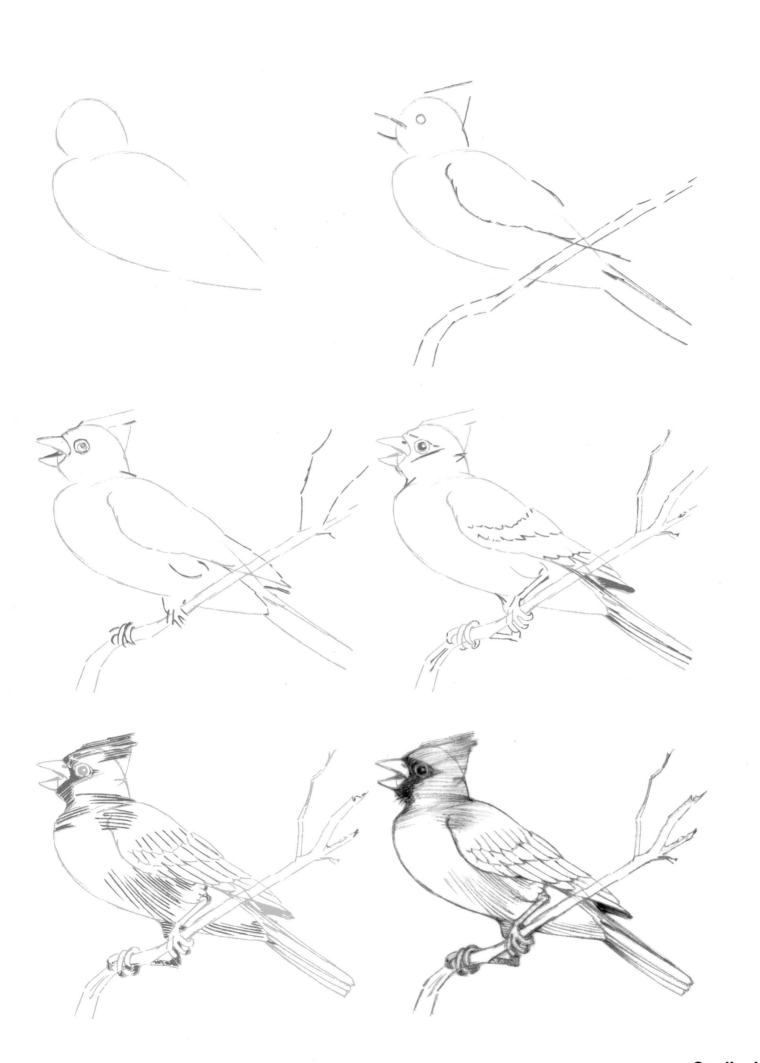

Cardinal

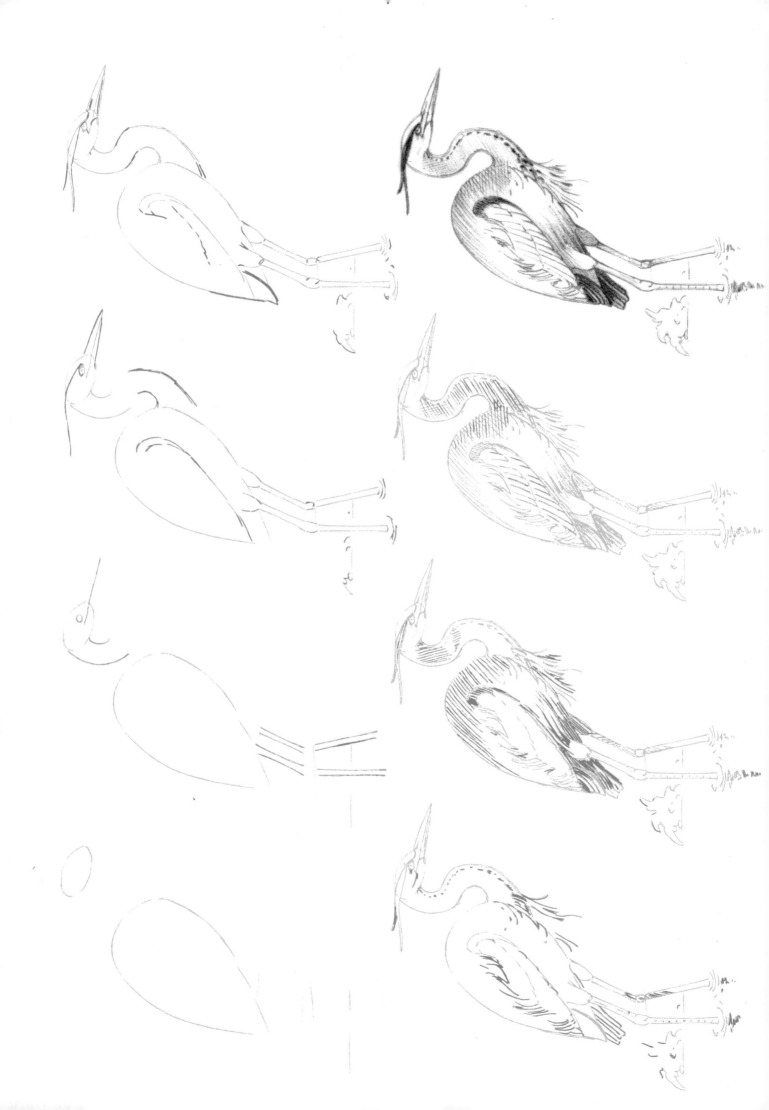

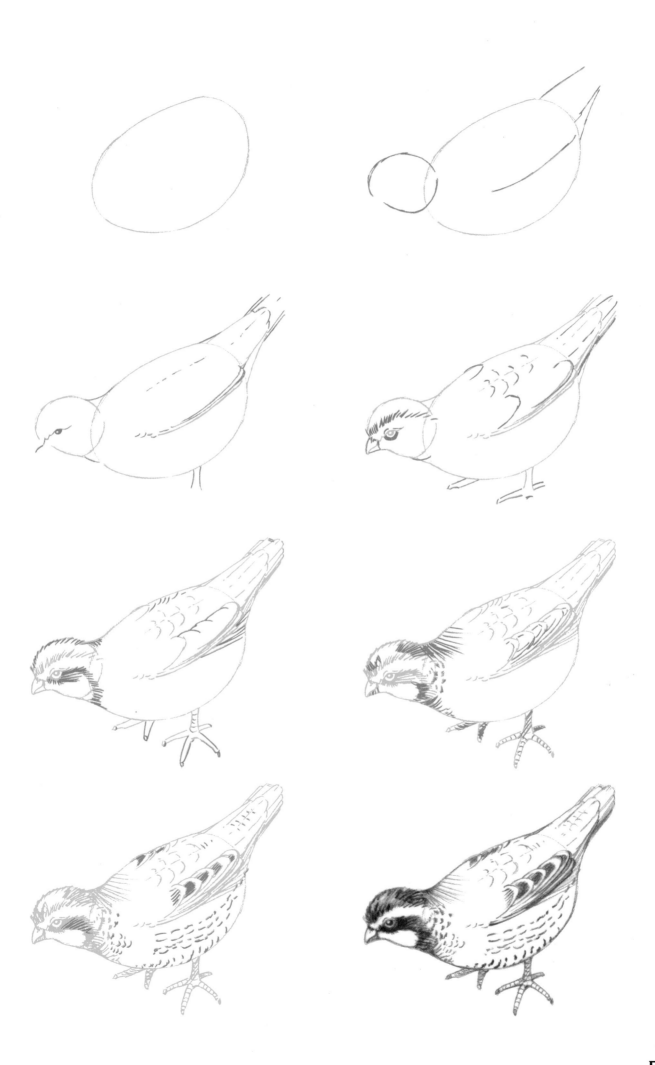

Bobwhite

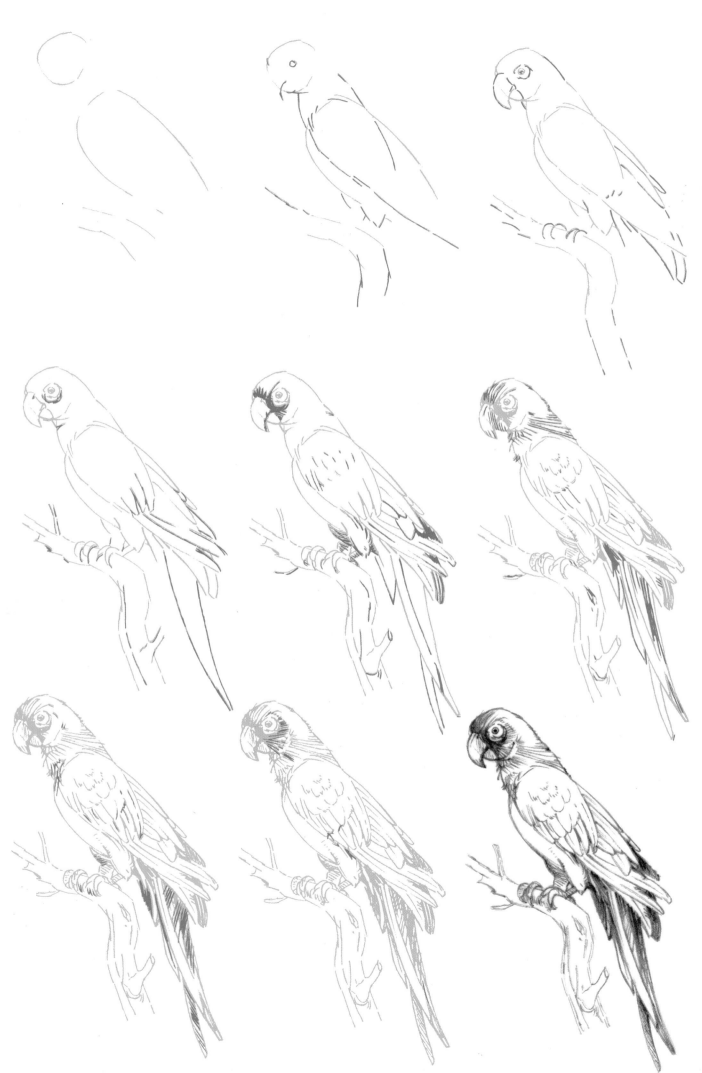

Macaw

Chickadee

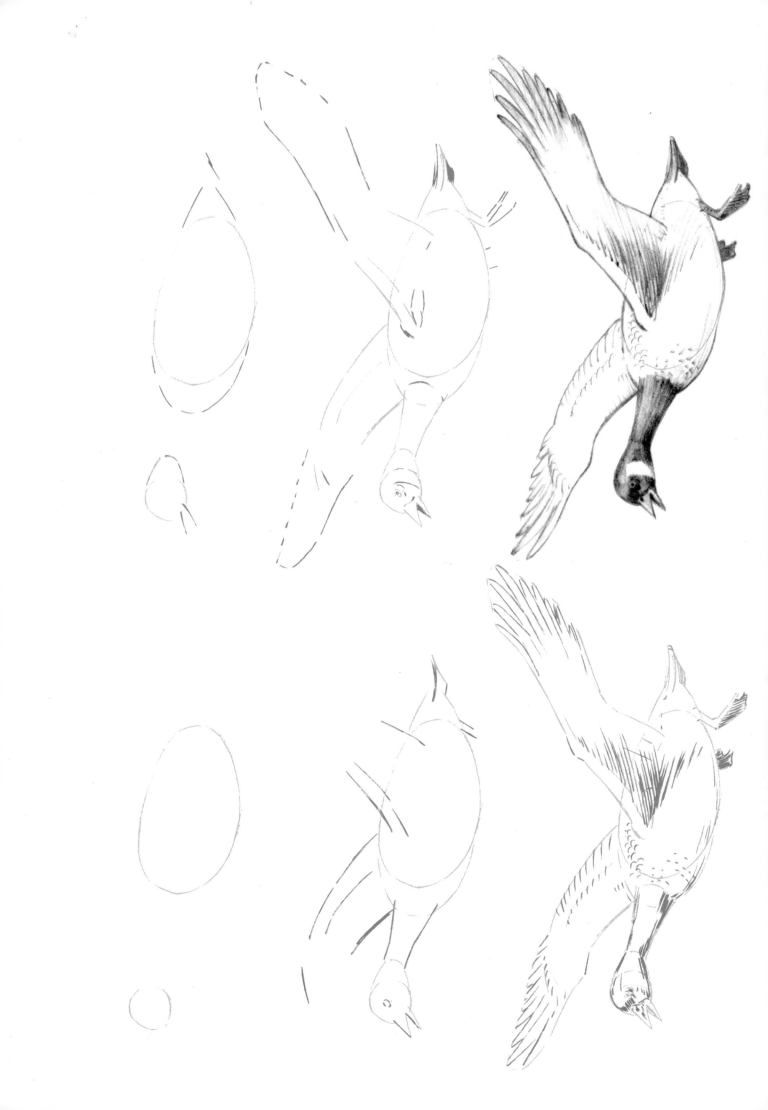

Meadowlark

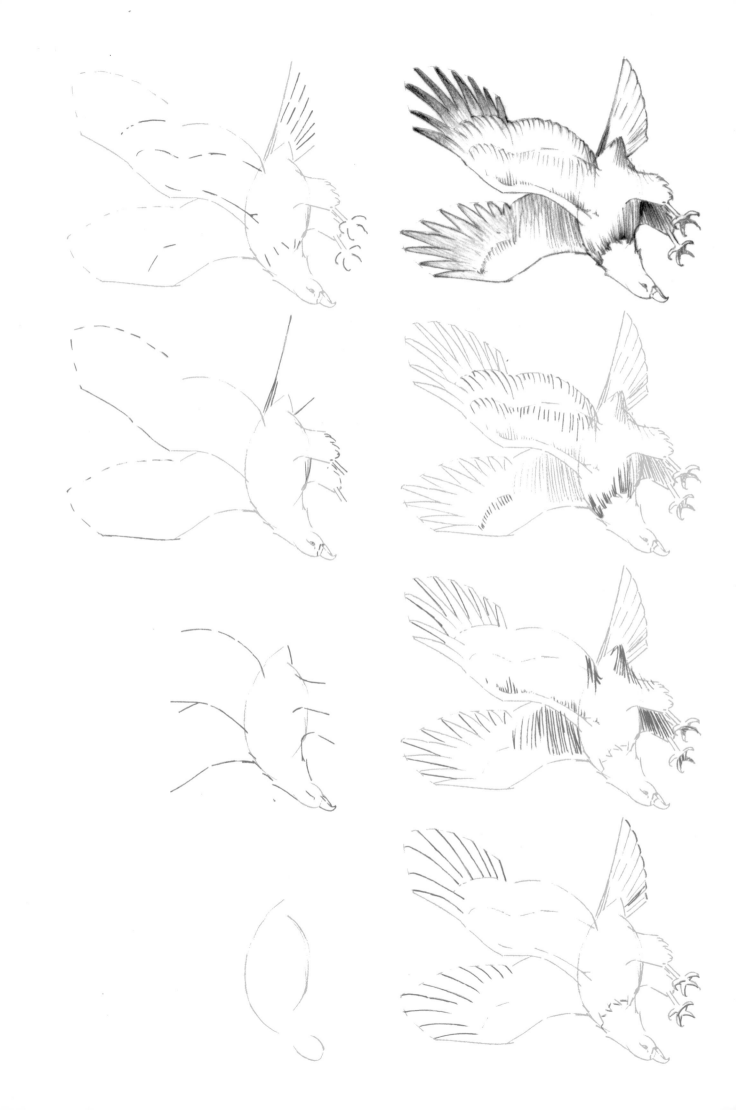

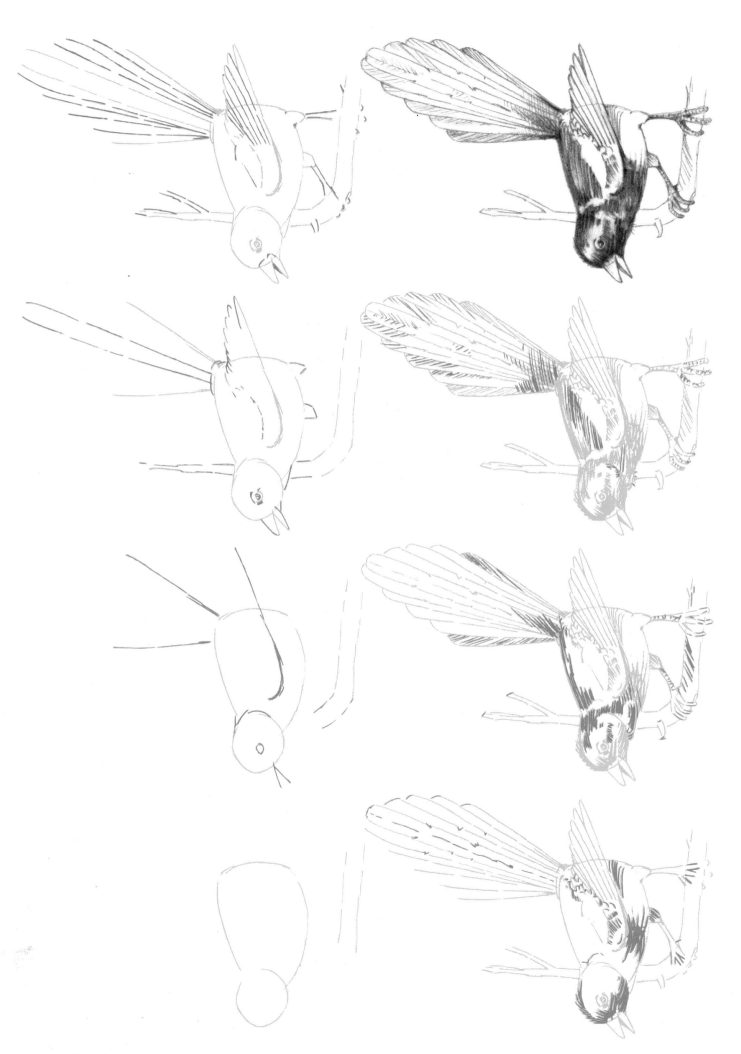

Magpie

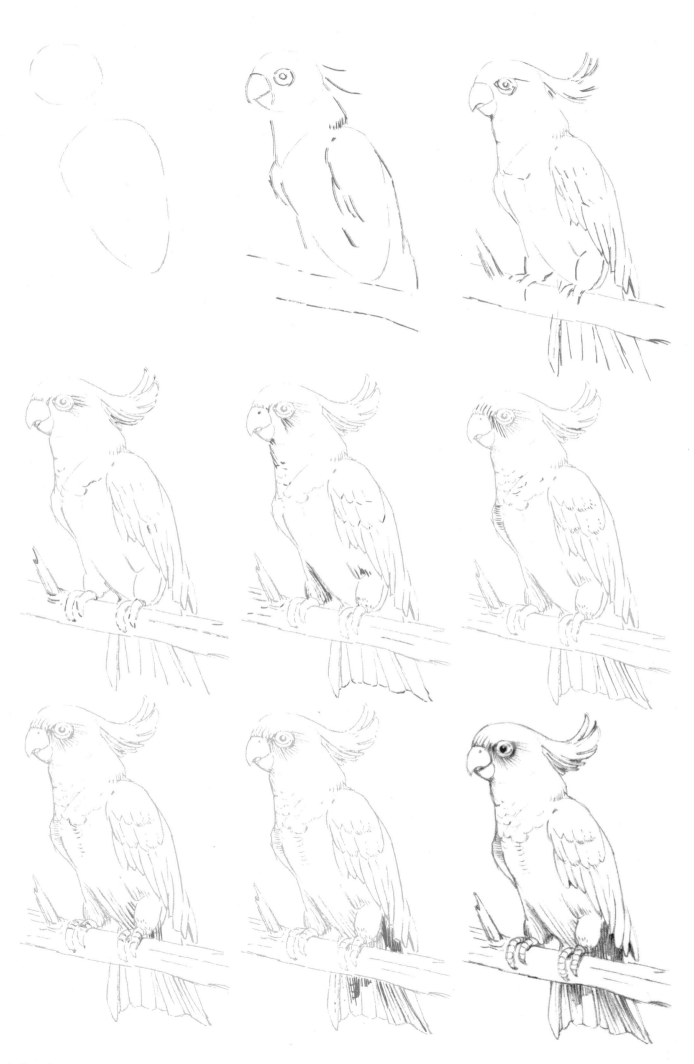

Plumed Cockatoo

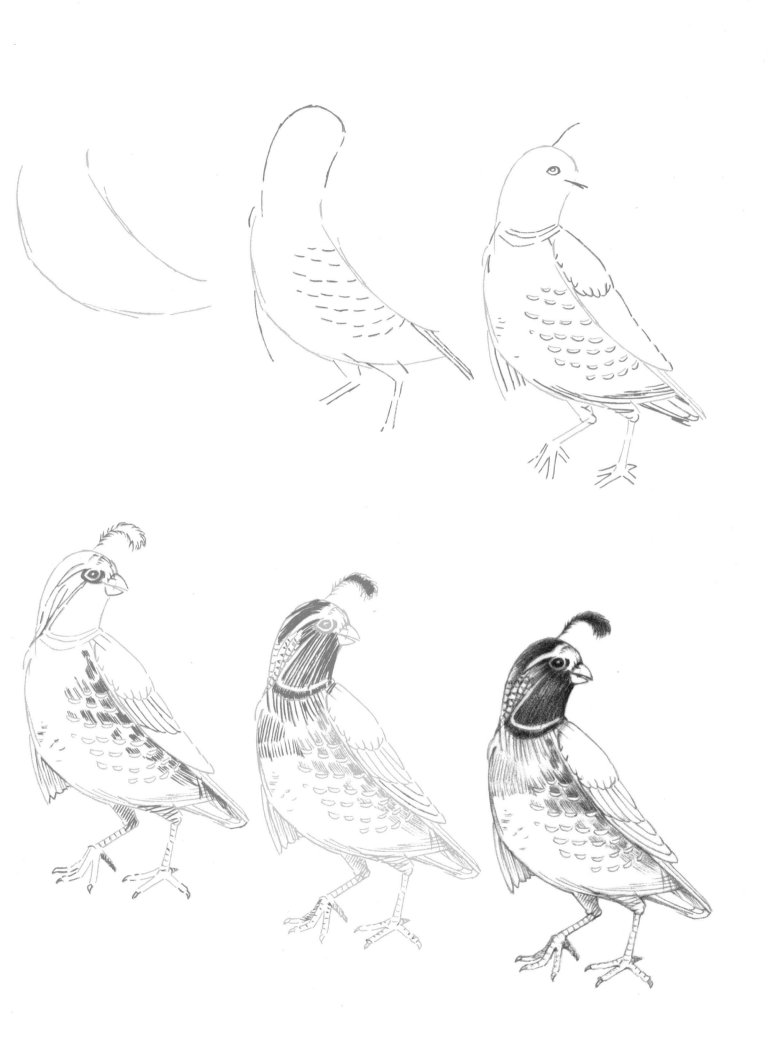

California Valley Quail

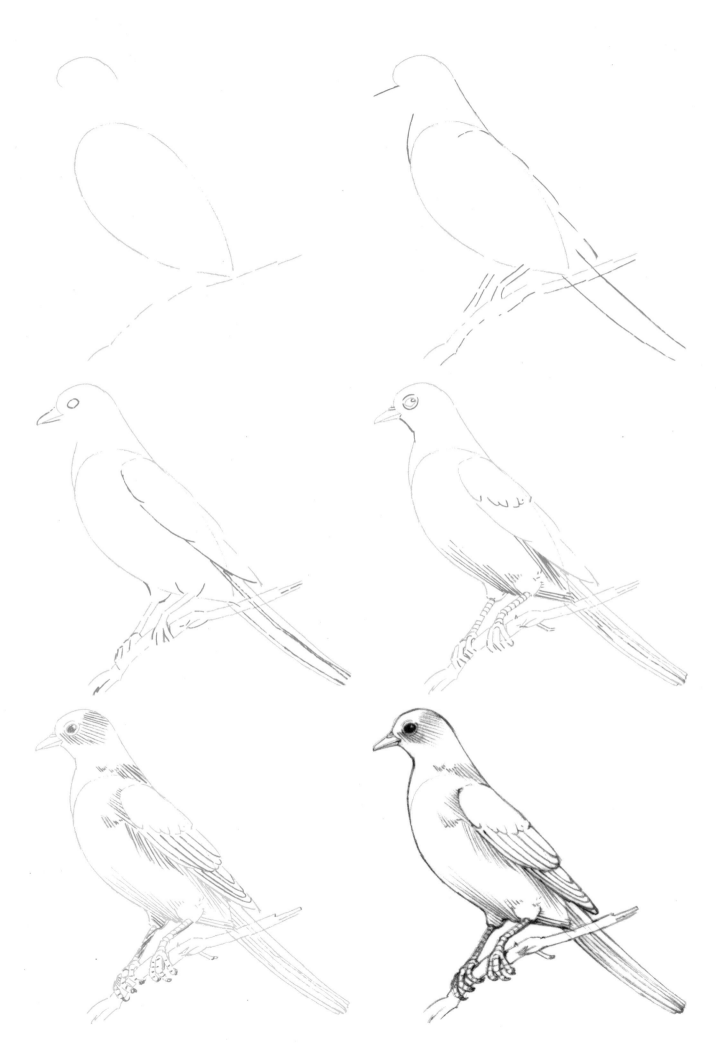

Mourning Dove

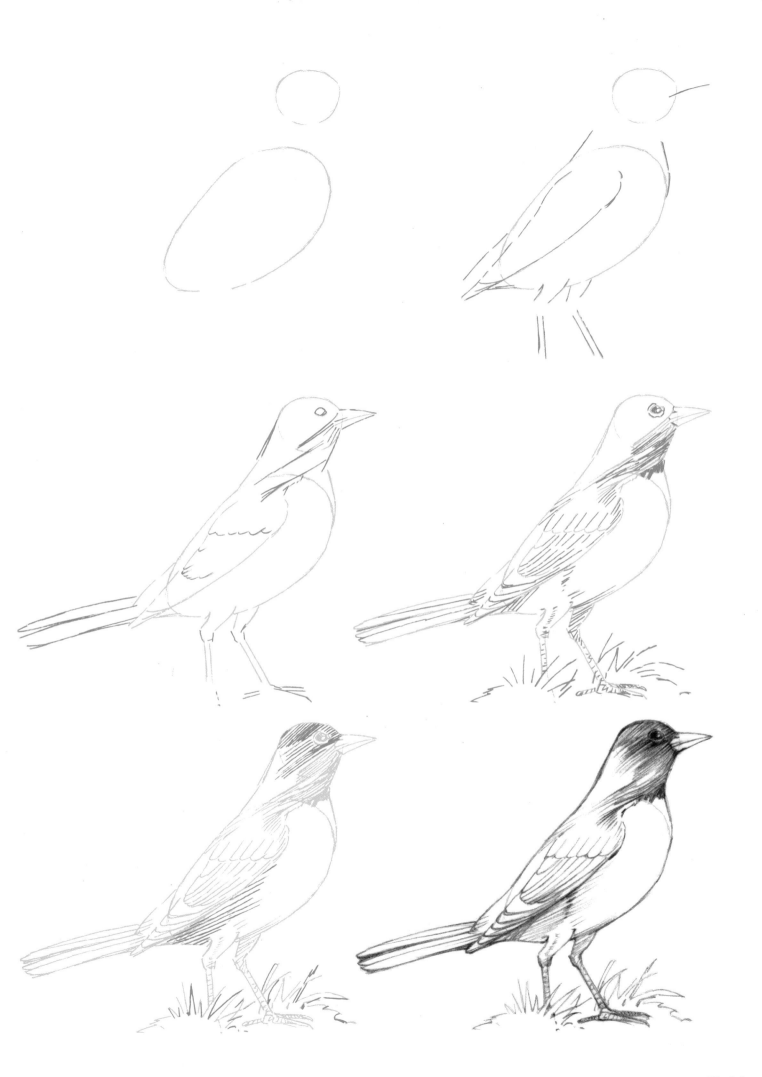

Robin

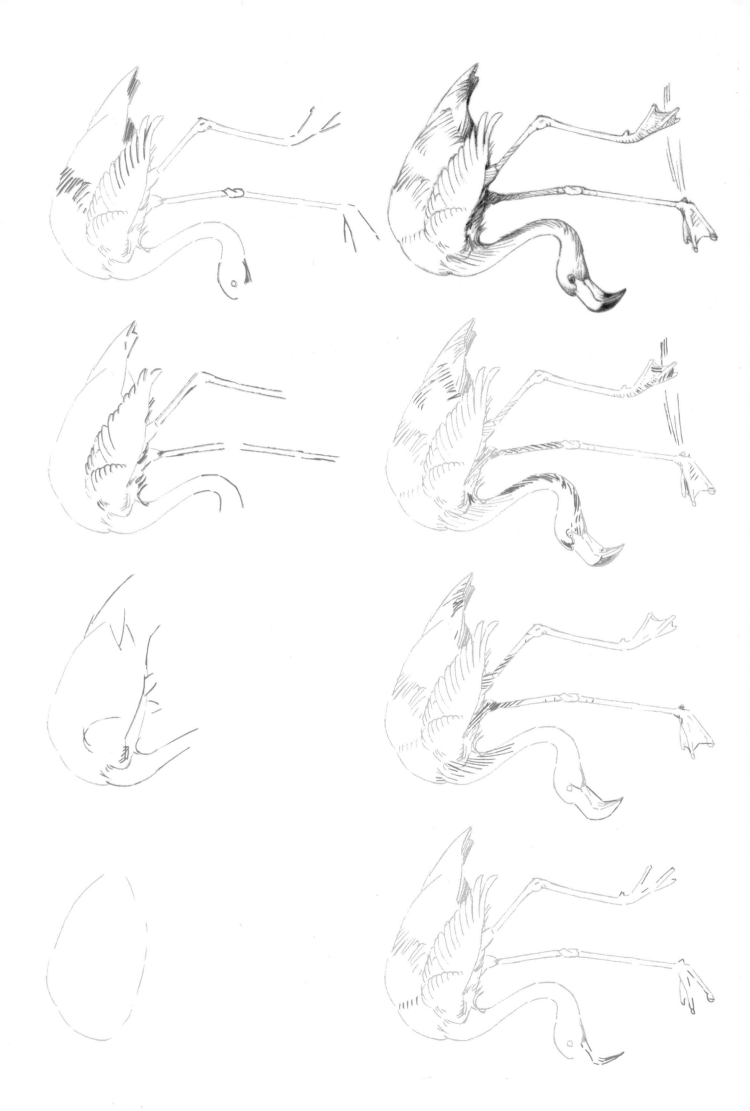

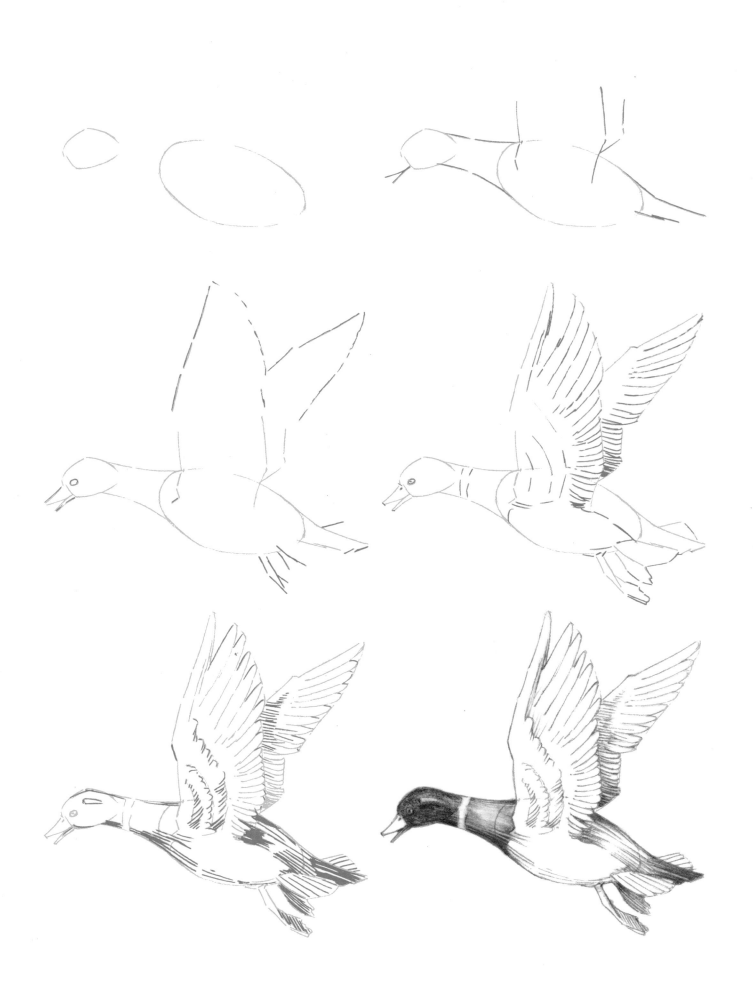

Mallard

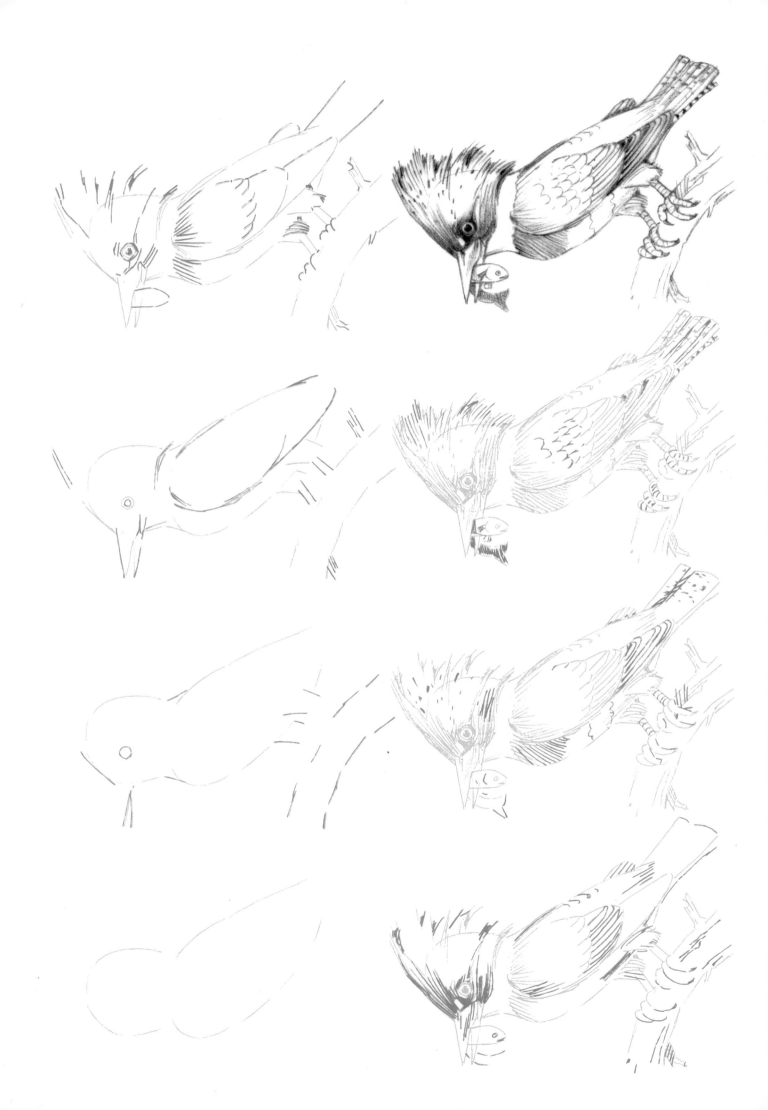

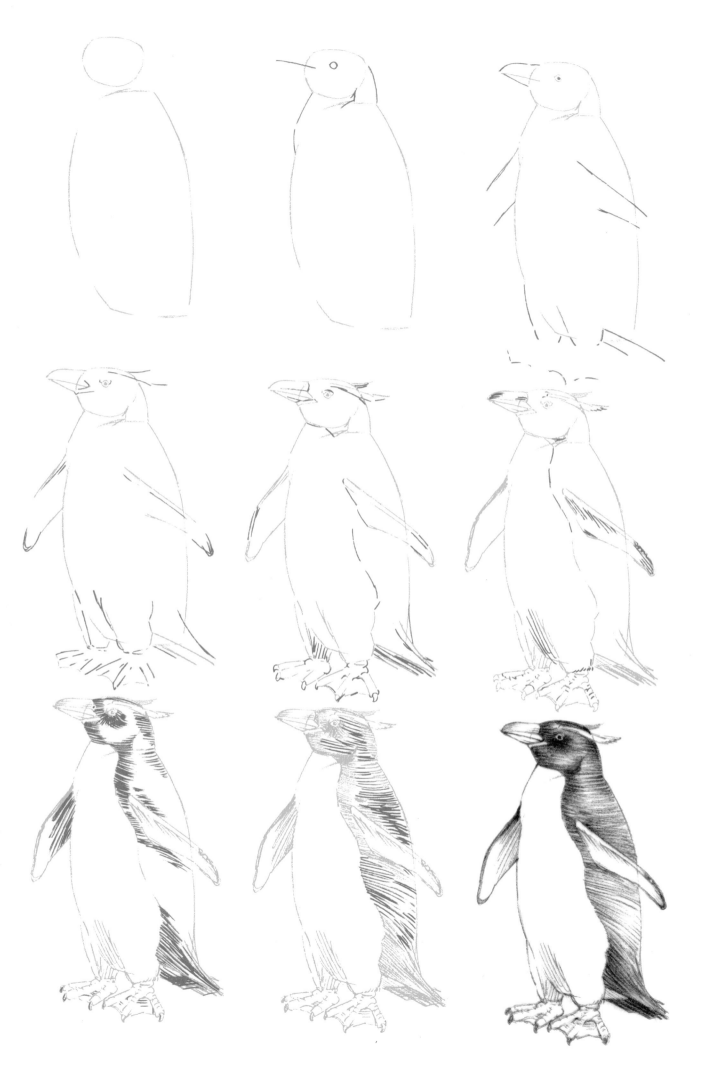

Macaroni Penguin

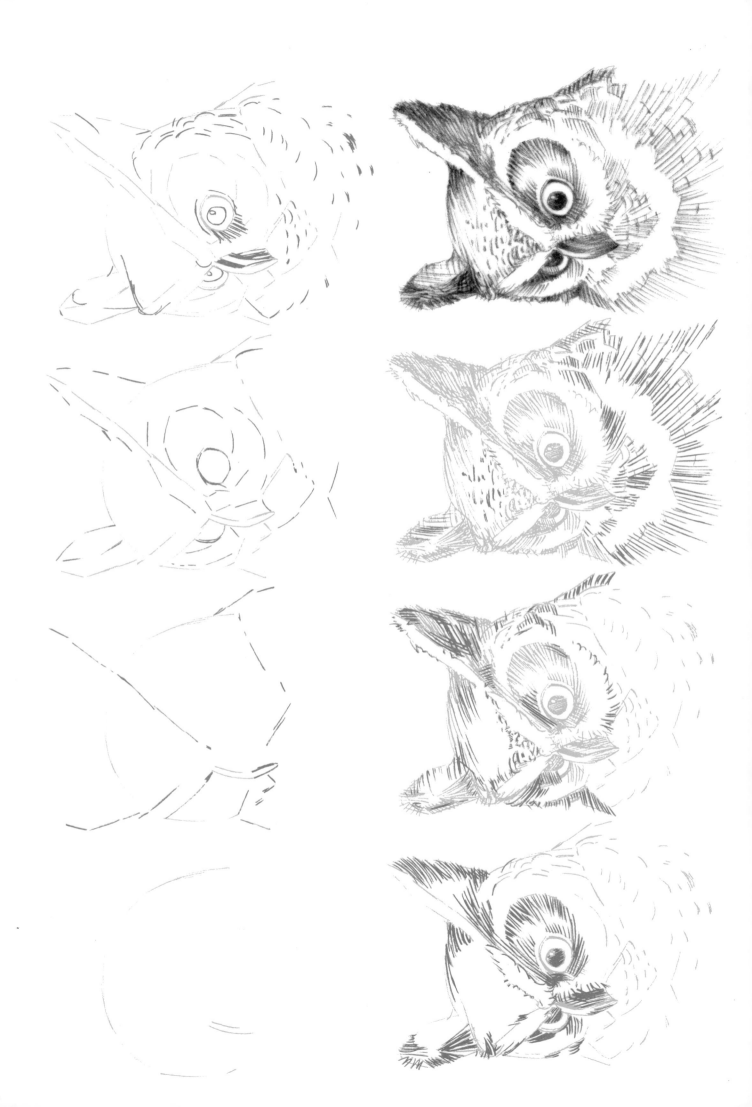

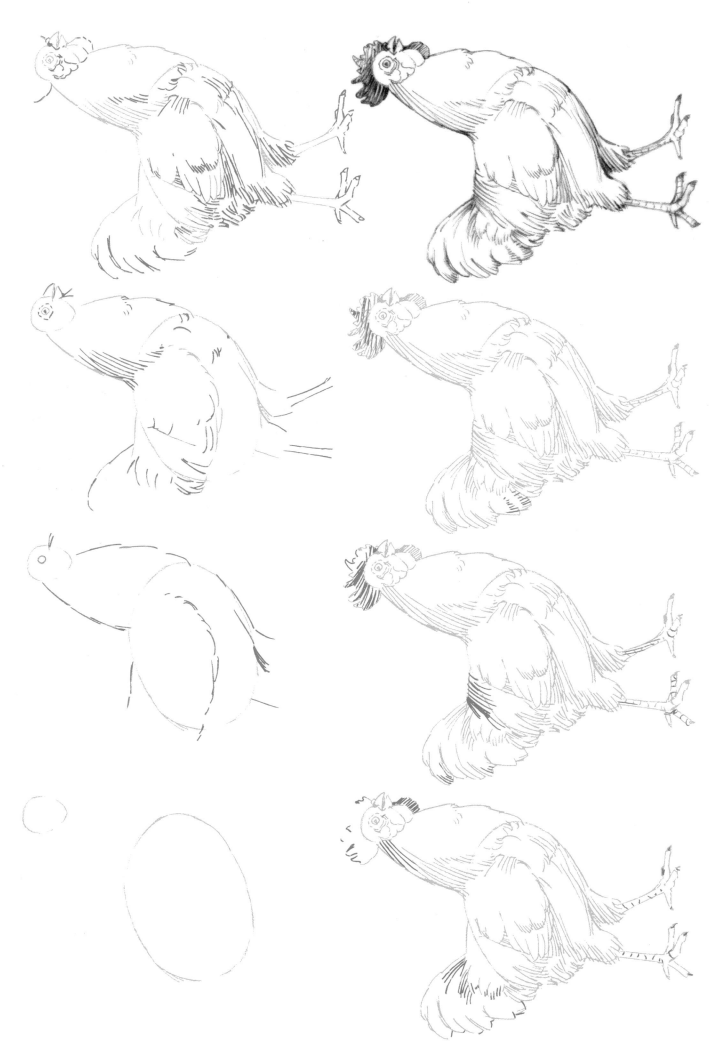

Cockerel

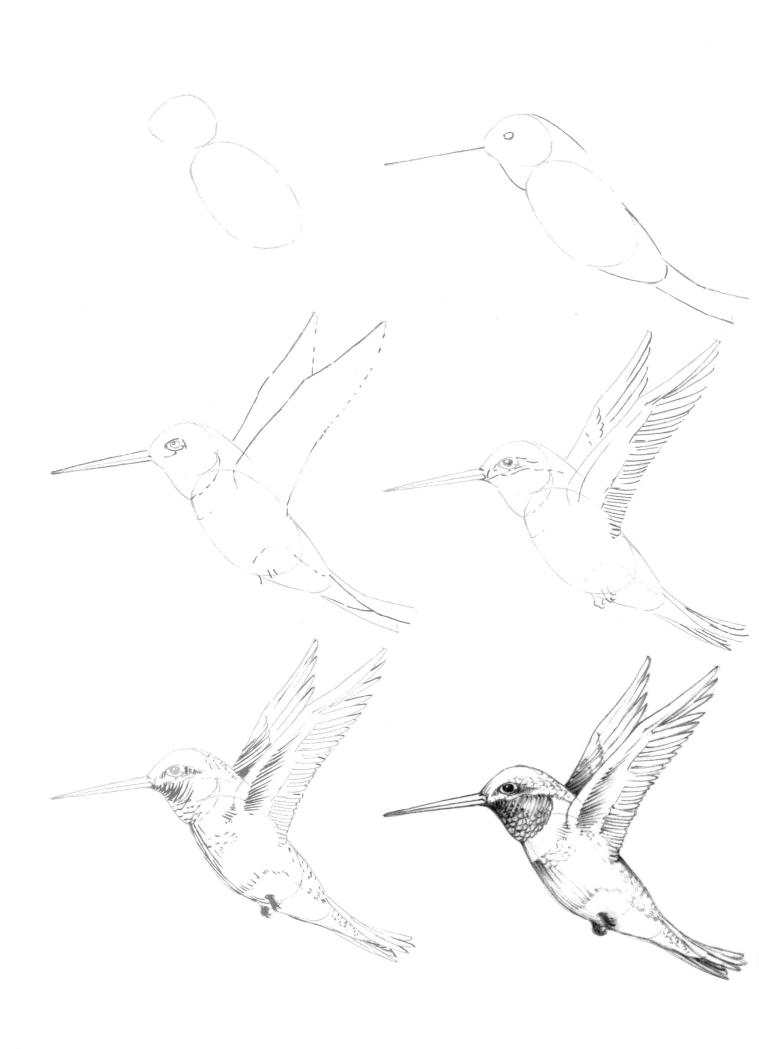

Ruby-throated Hummingbird

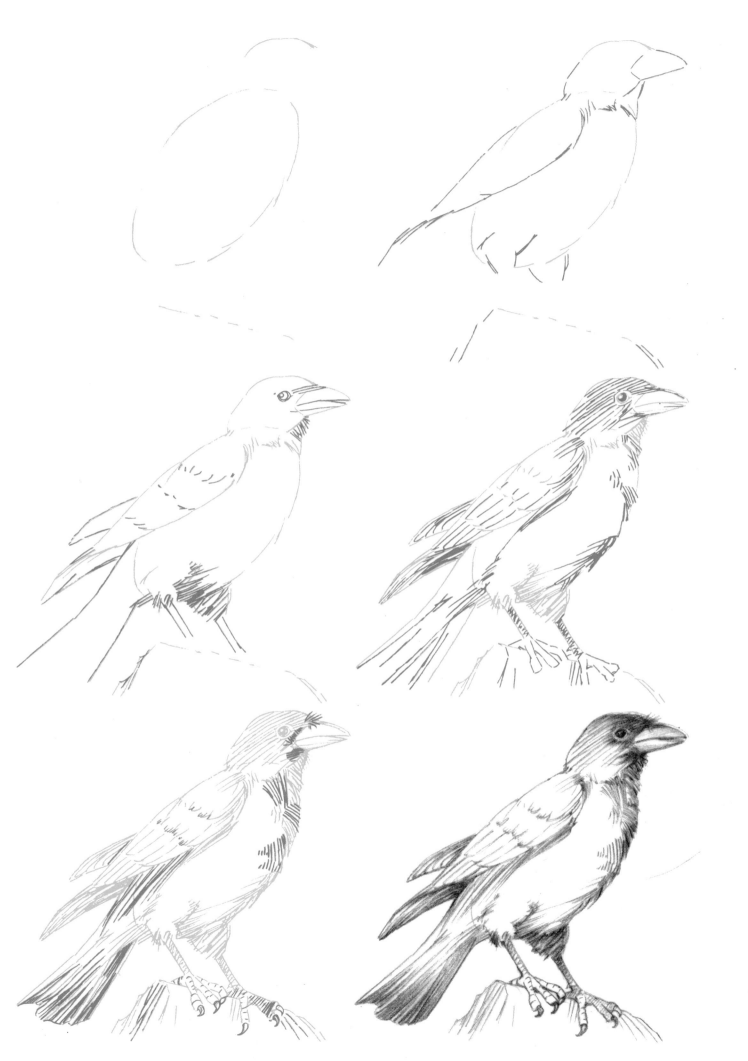

Raven

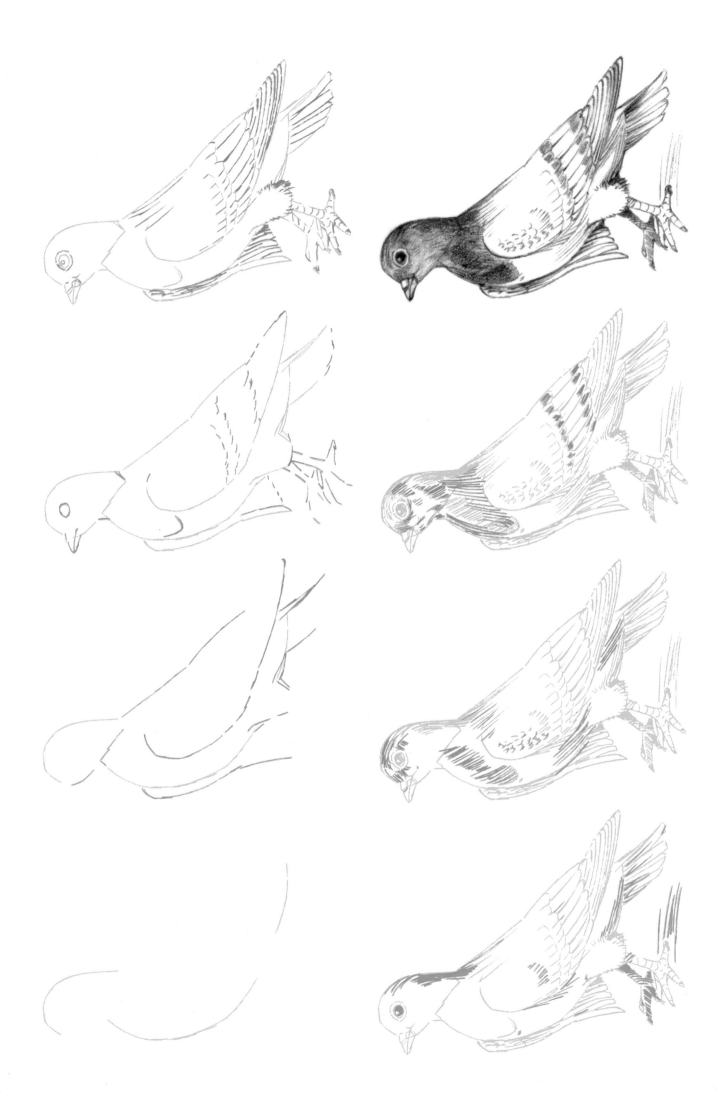

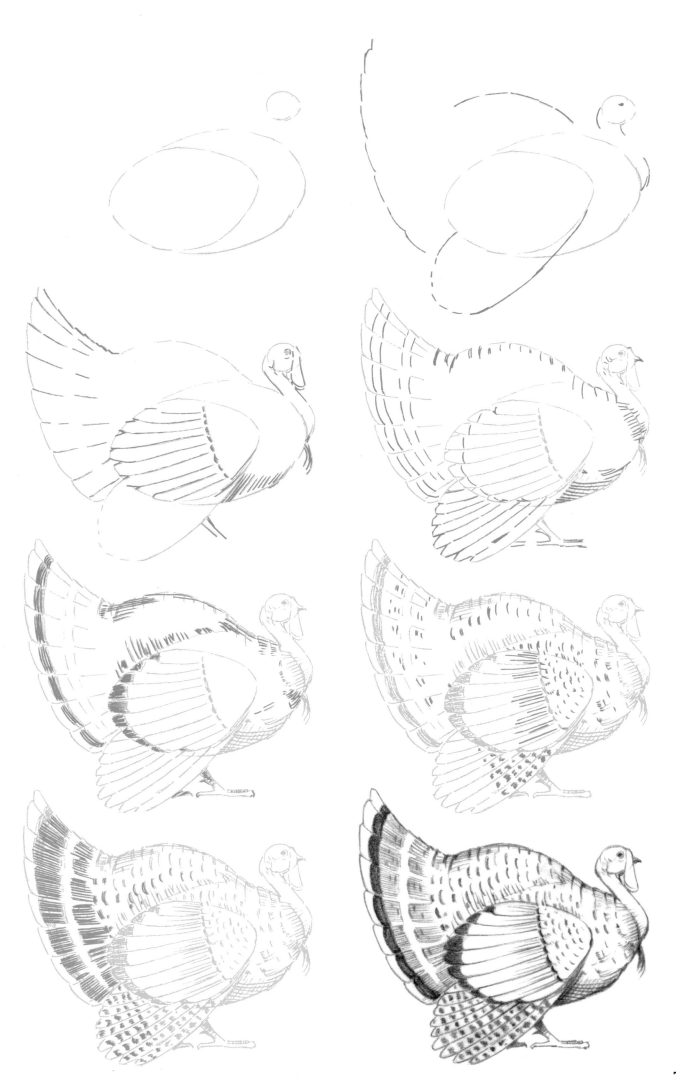

Turkey

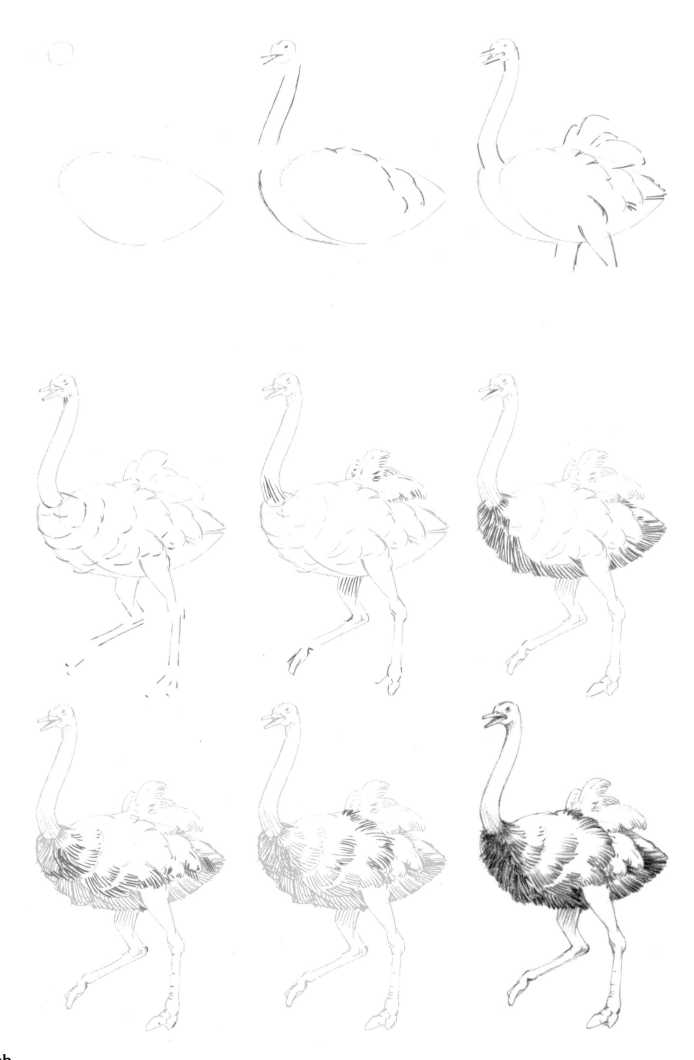

Ostrich

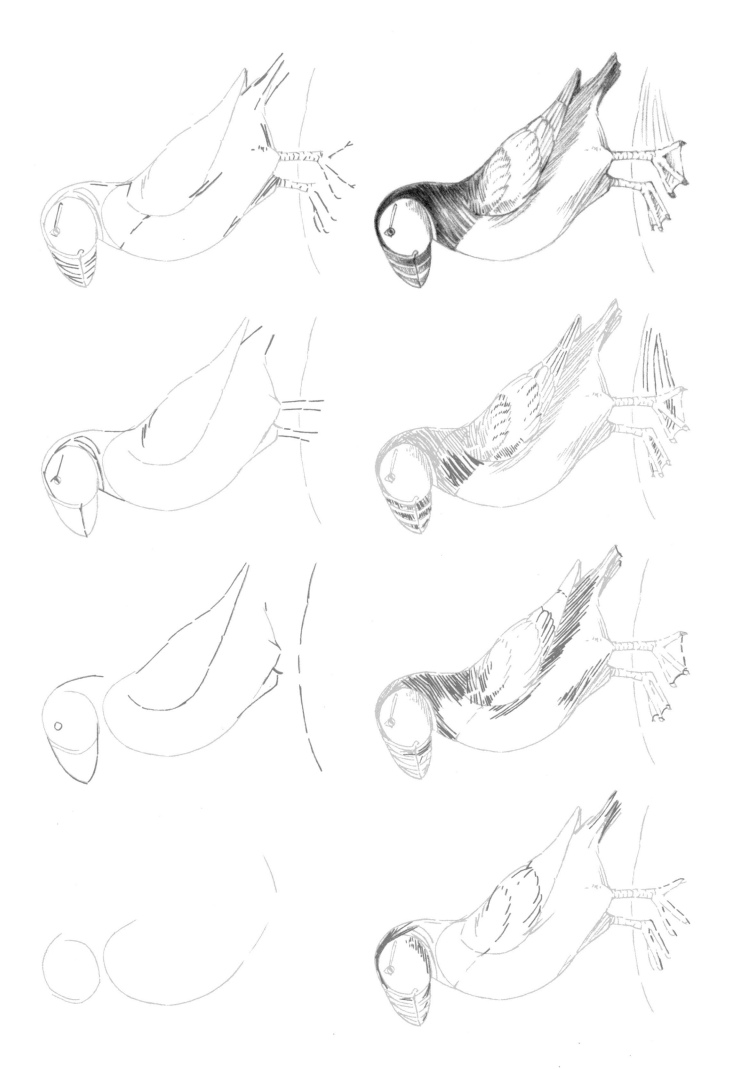

Puffin

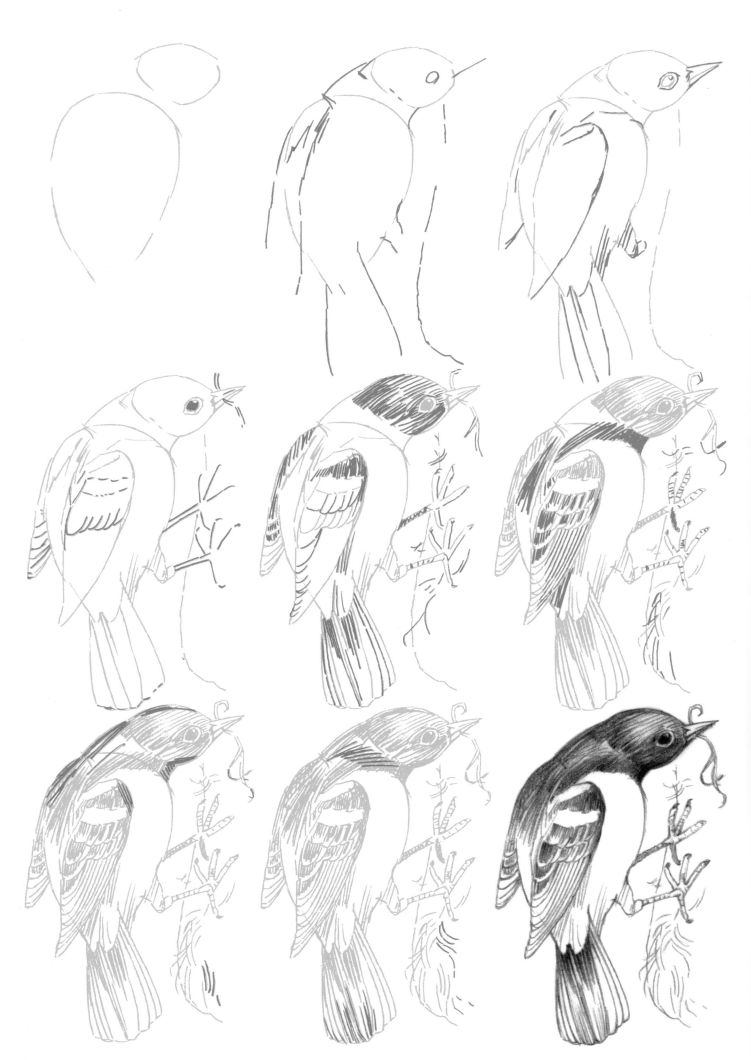

Oriole

Pheasant

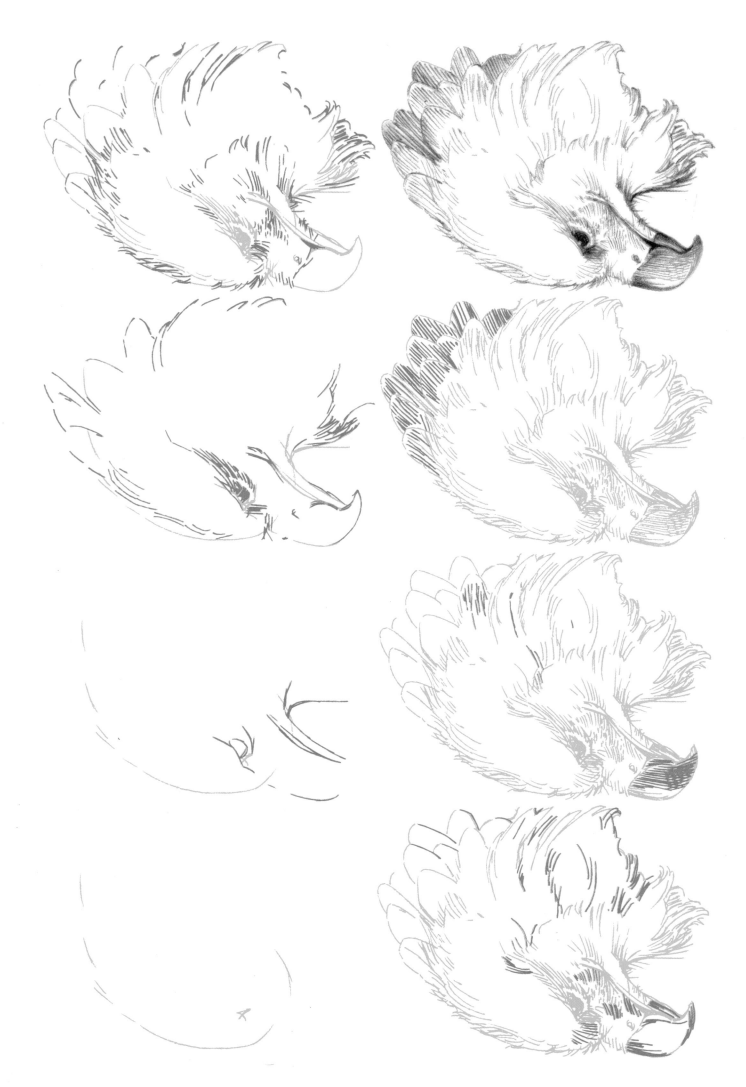

Red-tailed Hawk

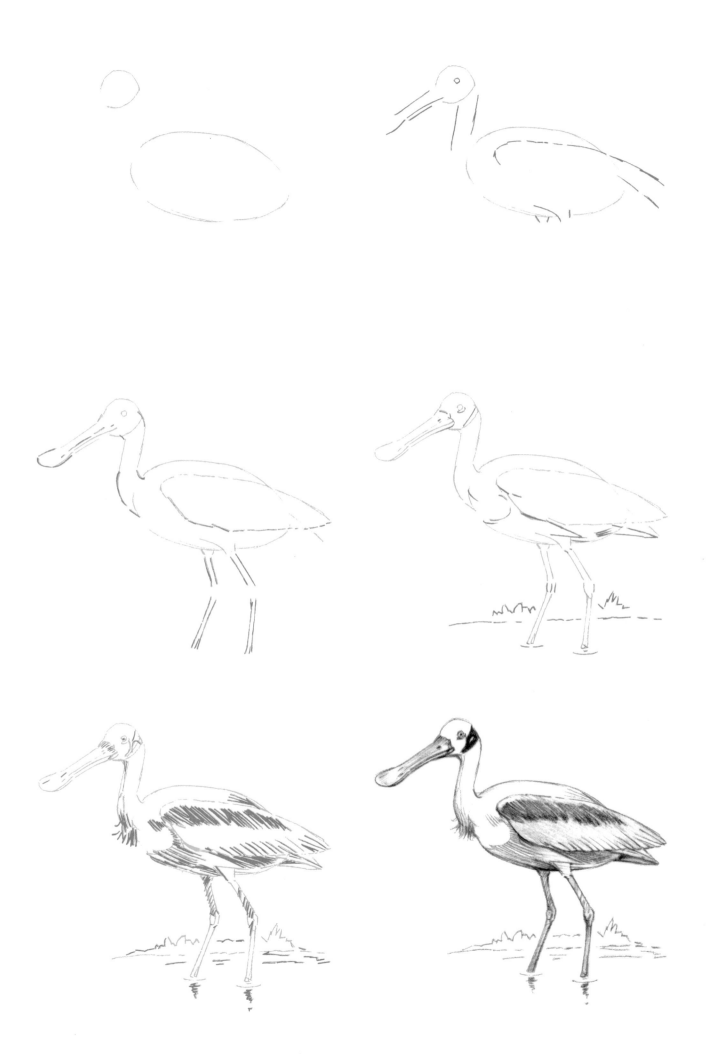

Spoonbill

Dodo (extinct since 1681)

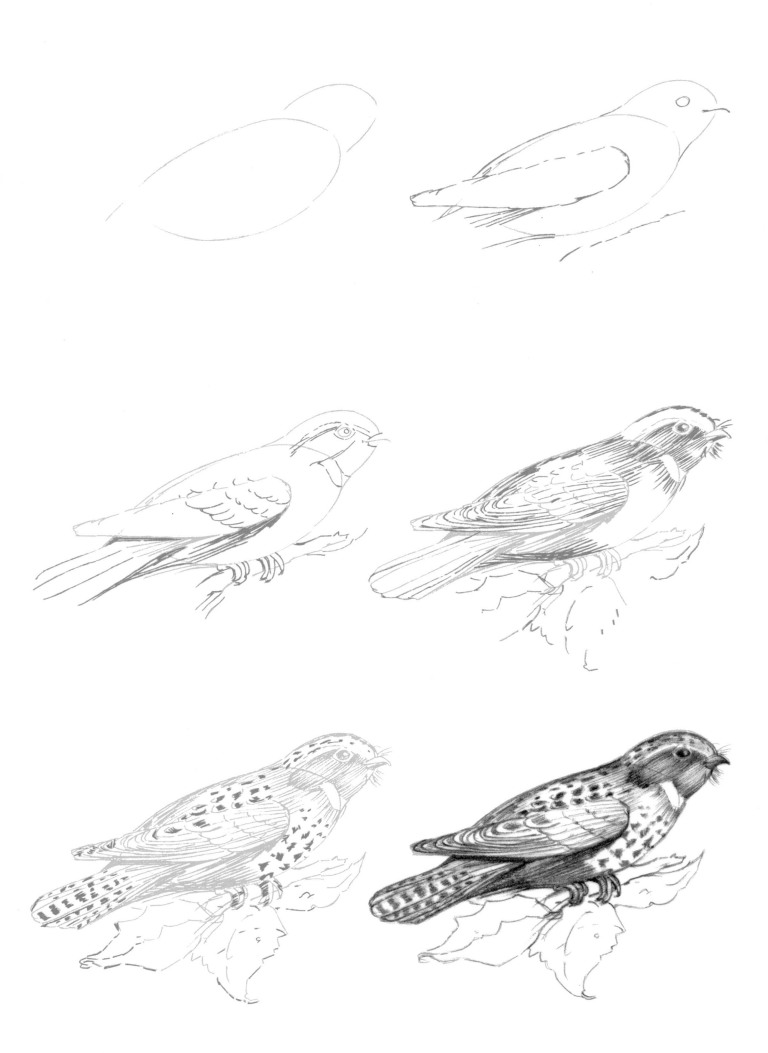

Whippoorwill

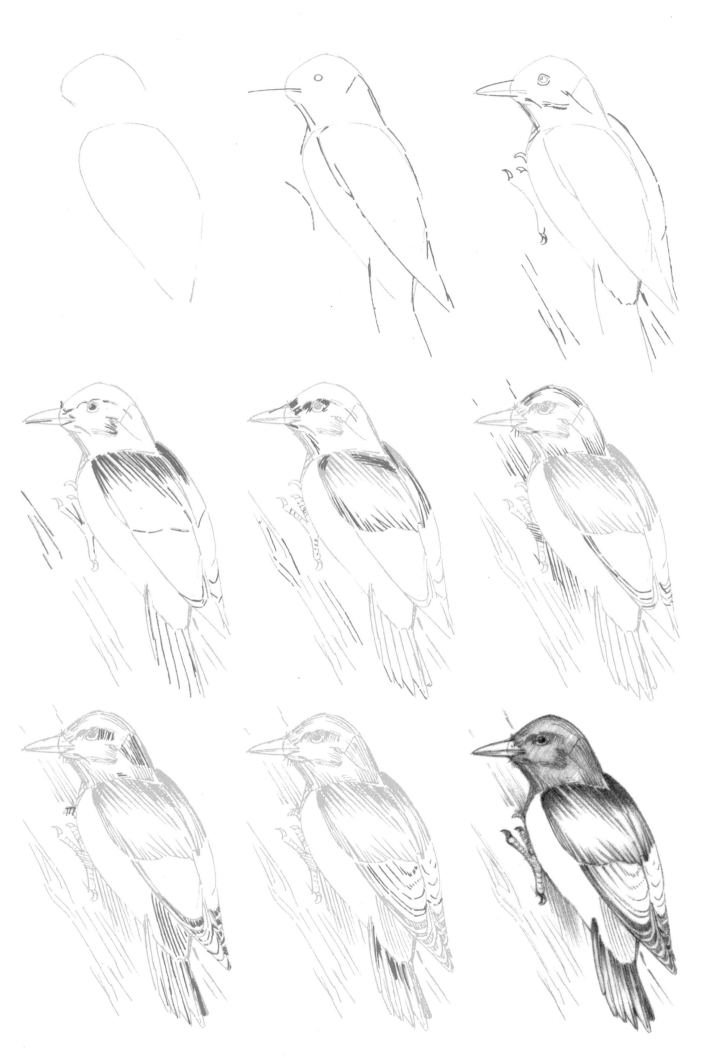

Woodpecker

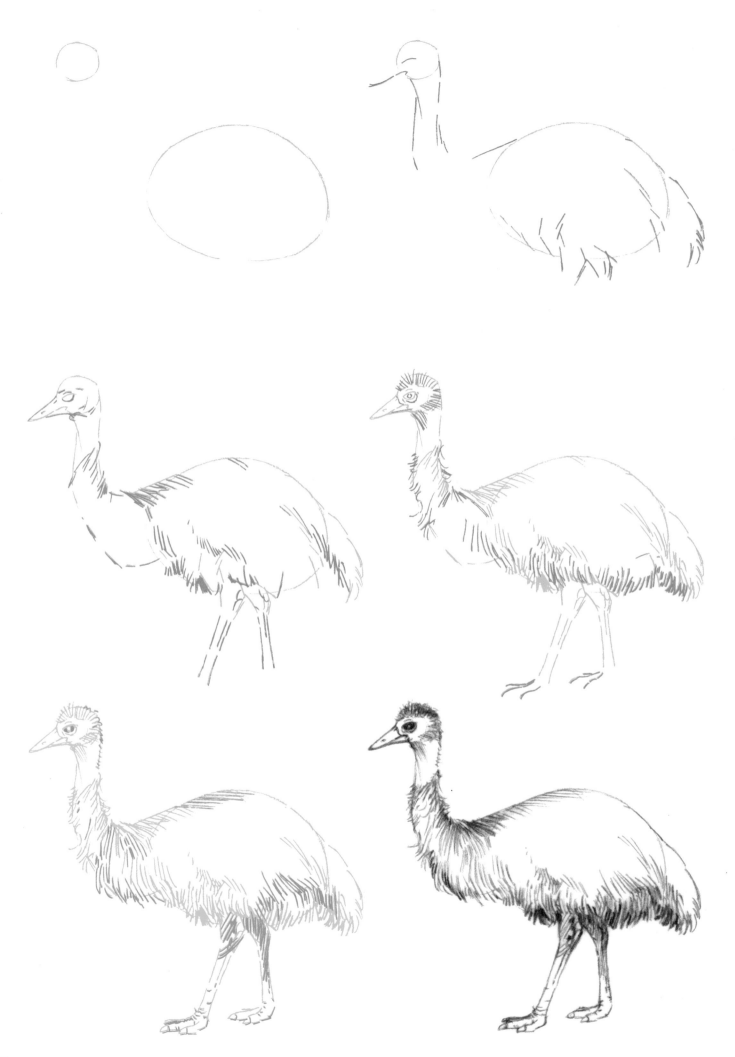

Emu

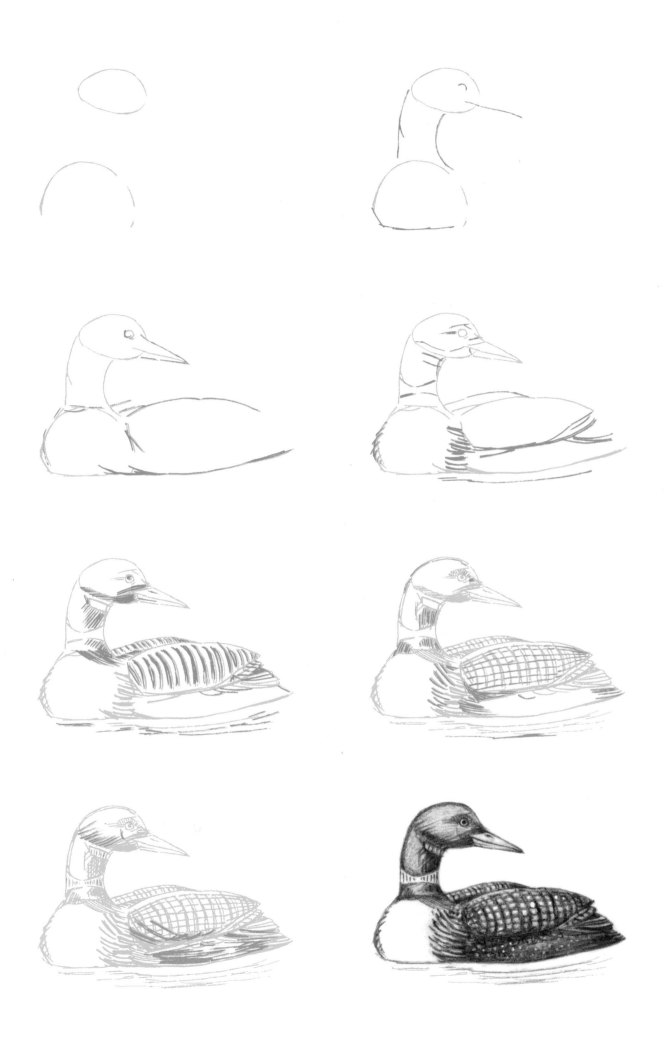

Common Loon

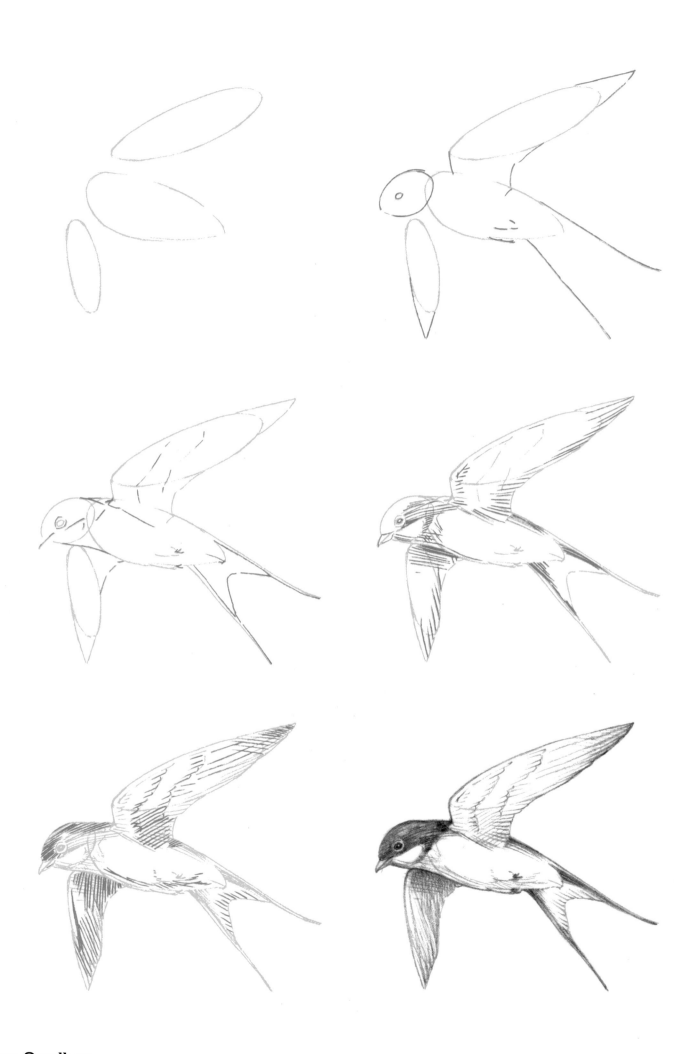

Barn Swallow

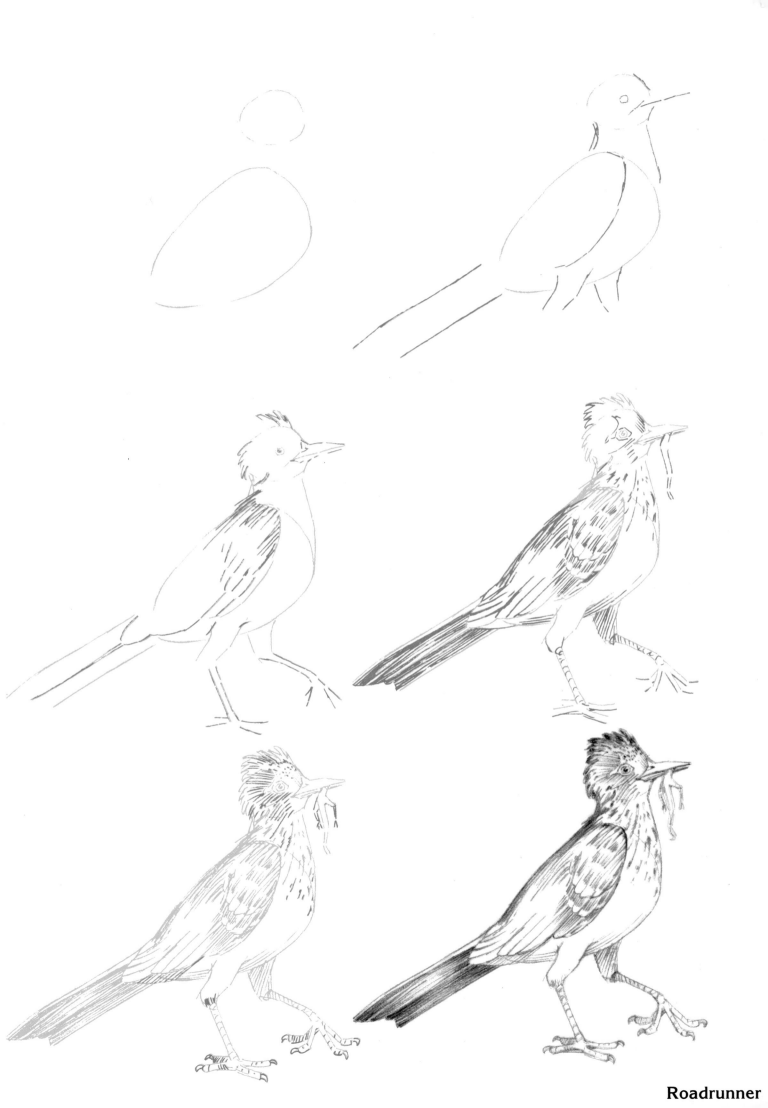

Roadrunner

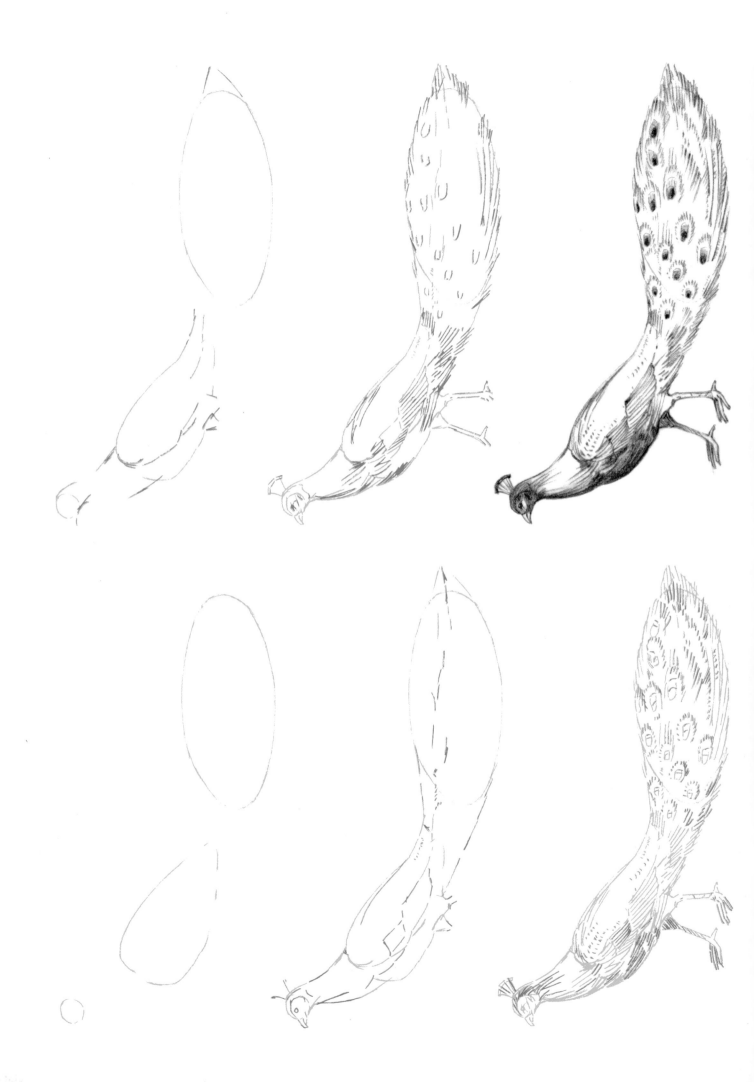

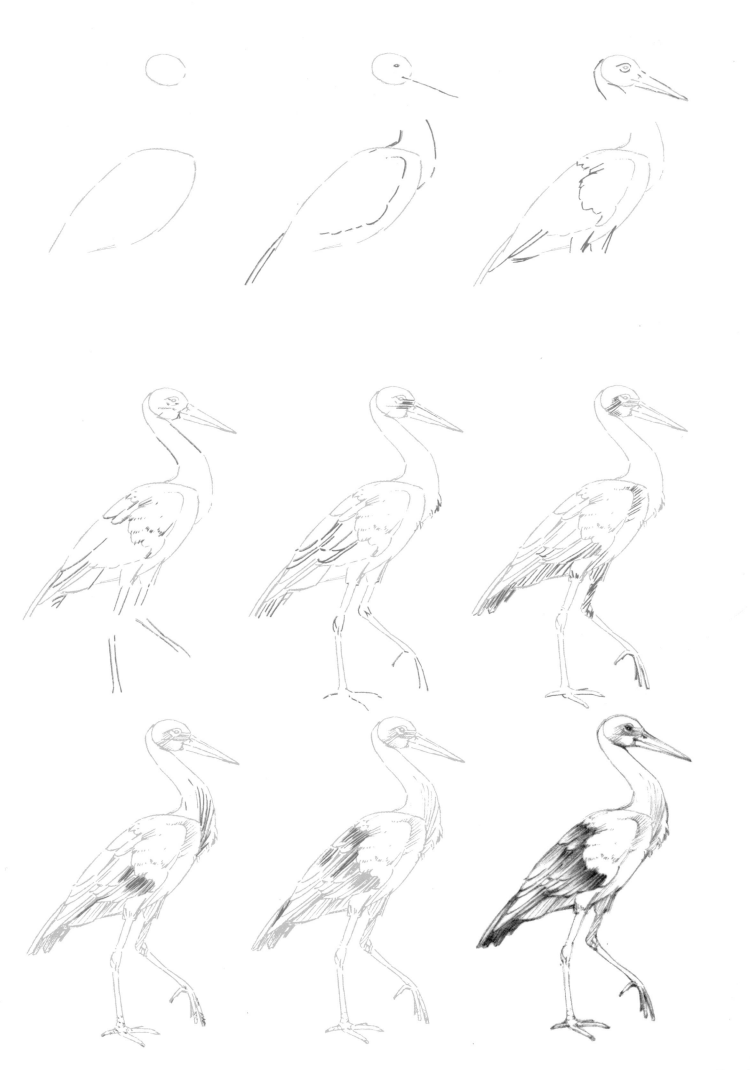

Stork

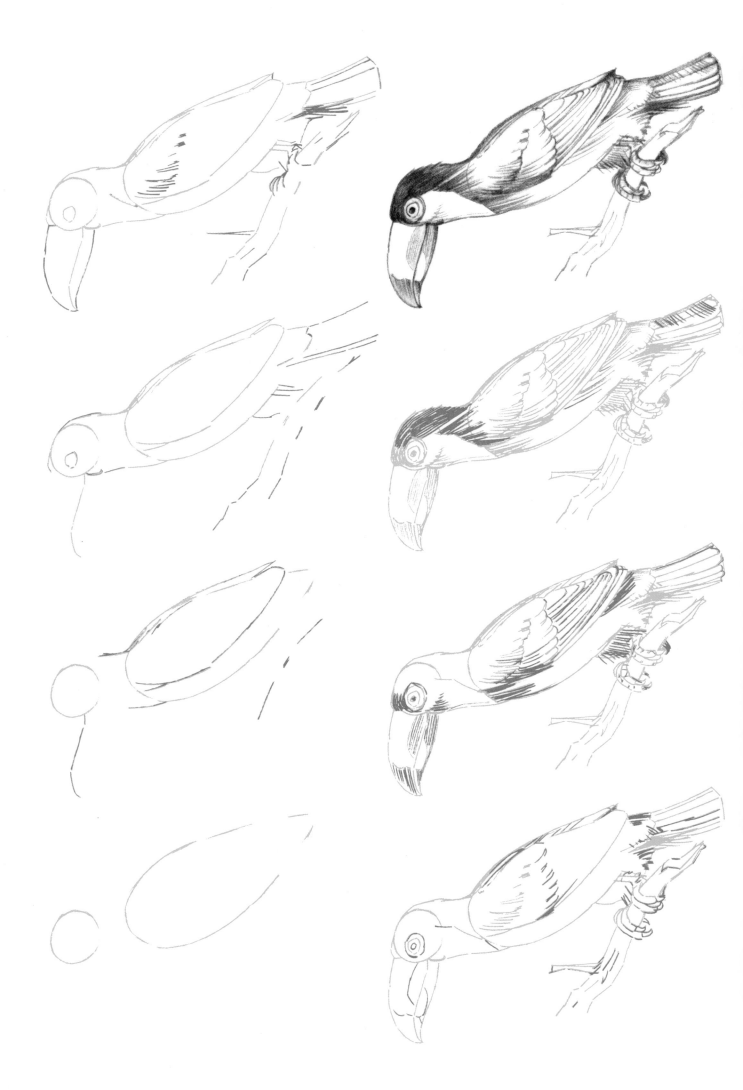

Marsh Wren

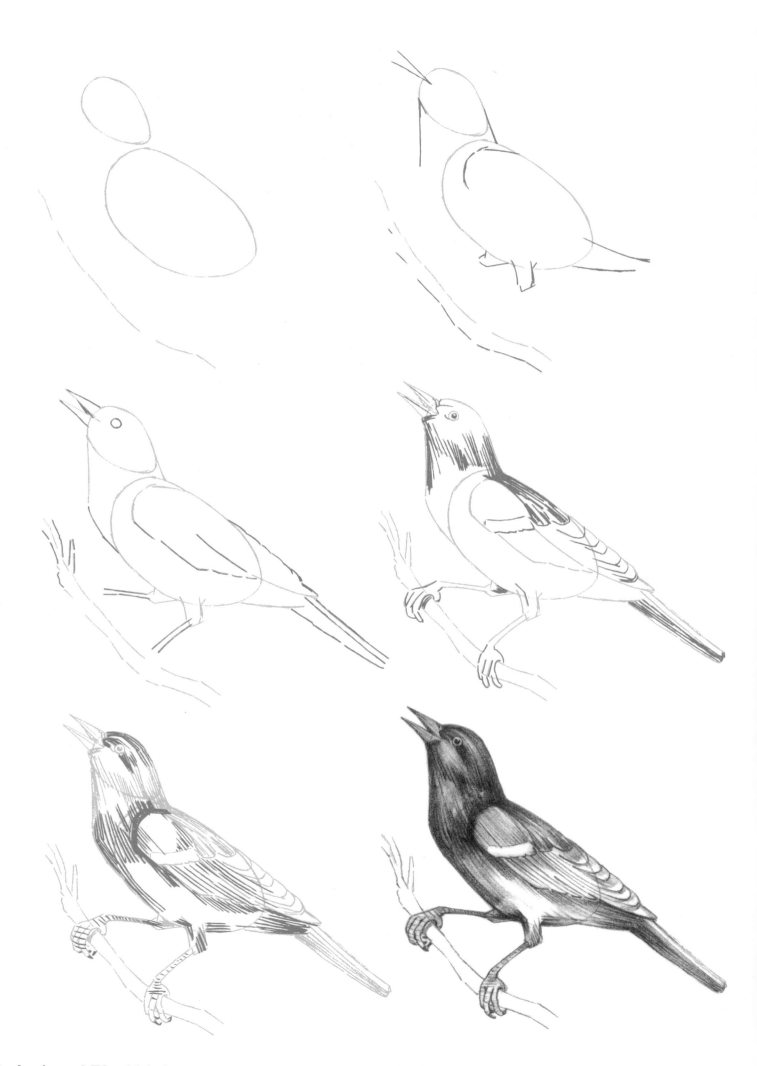

Red-winged Blackbird

Peregrine Falcon

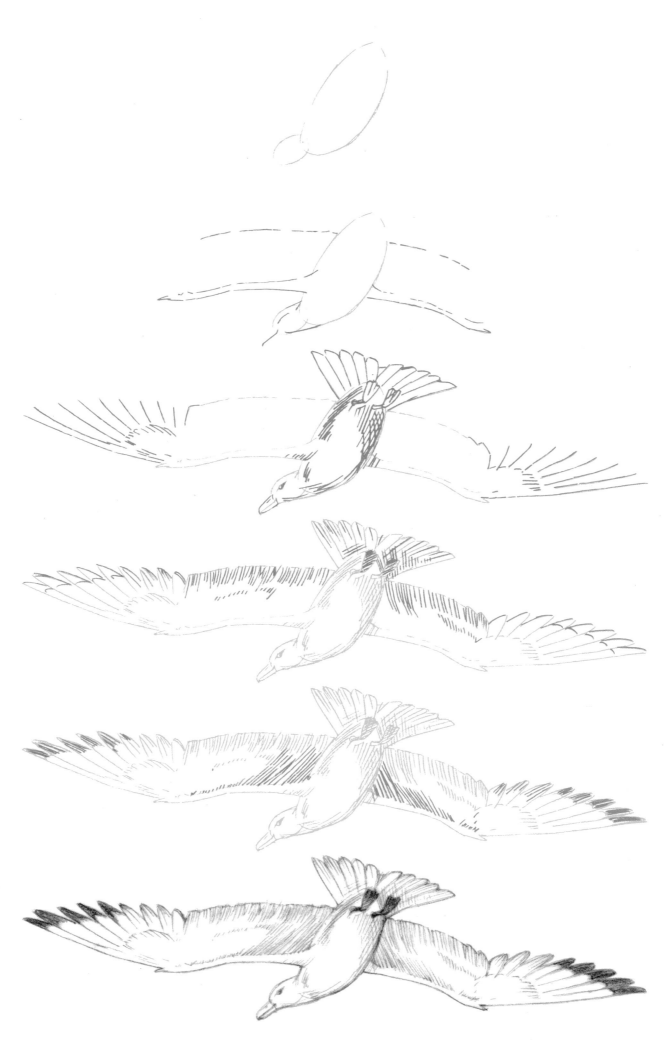

Herring Gull

Bird of Paradise

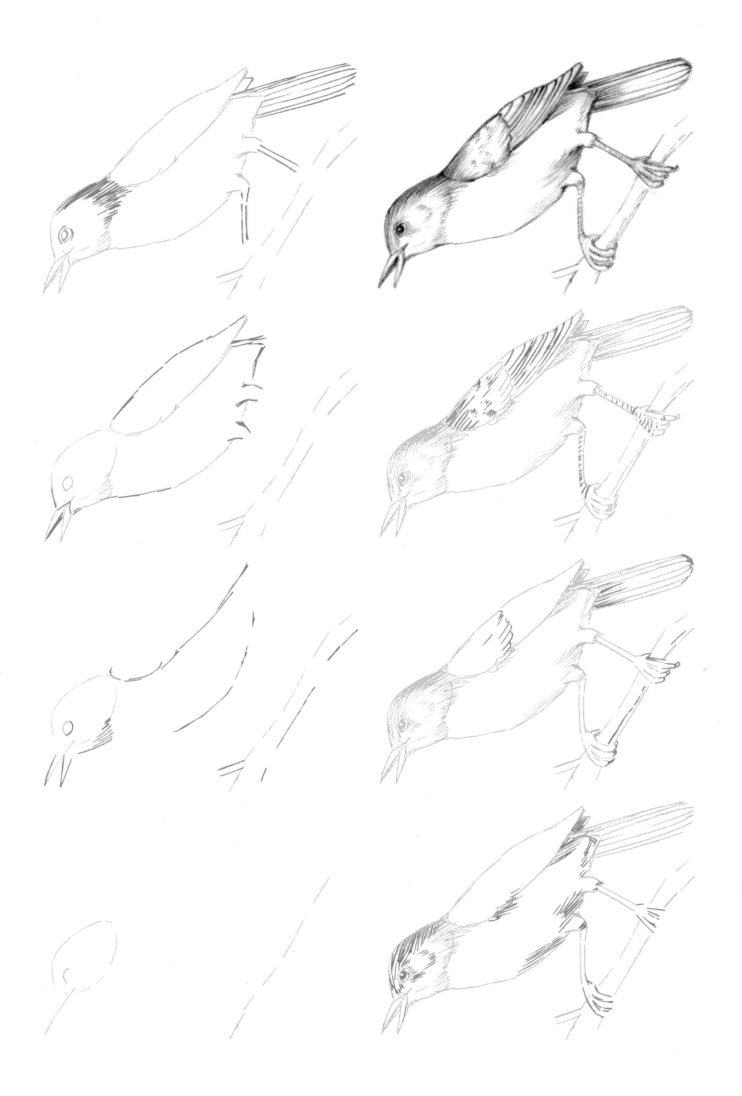

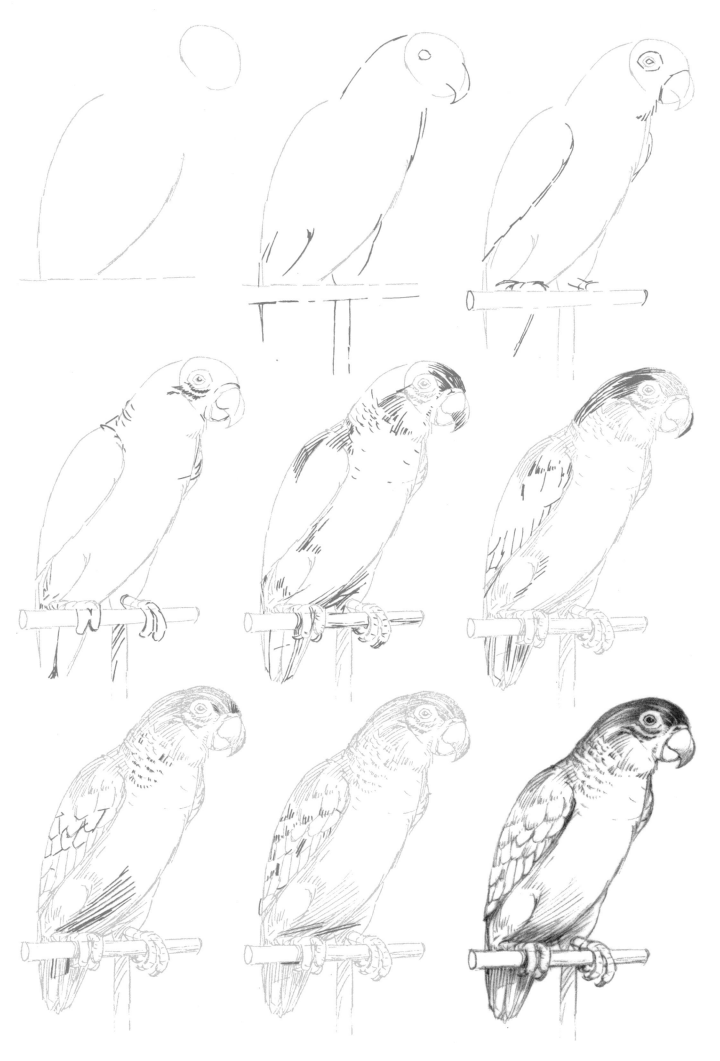

Parrot

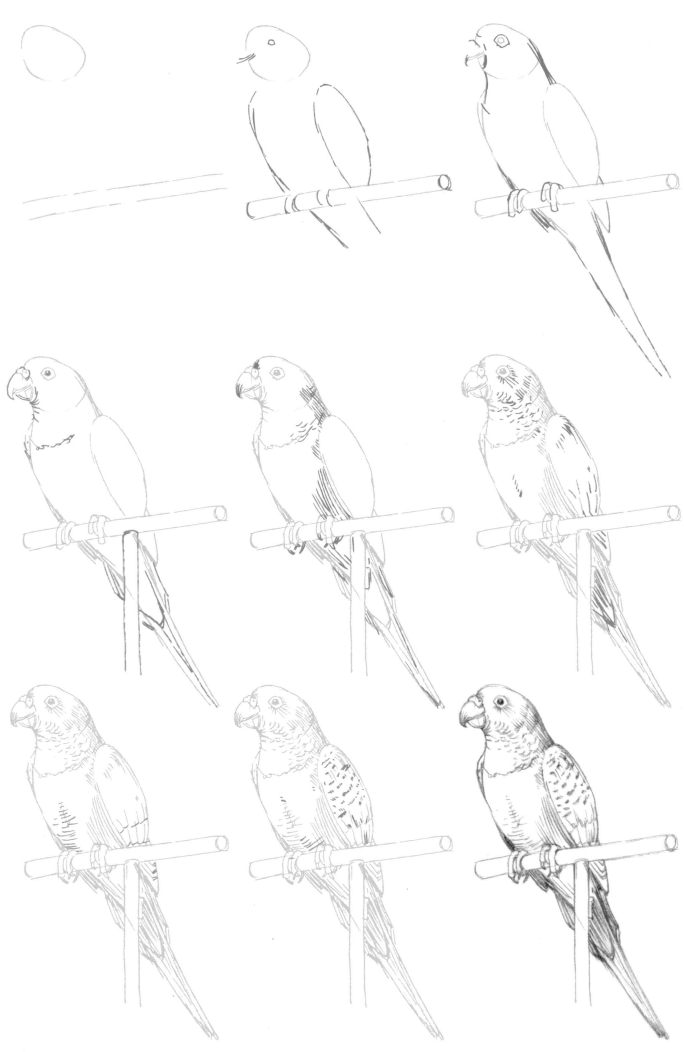

Parakeet

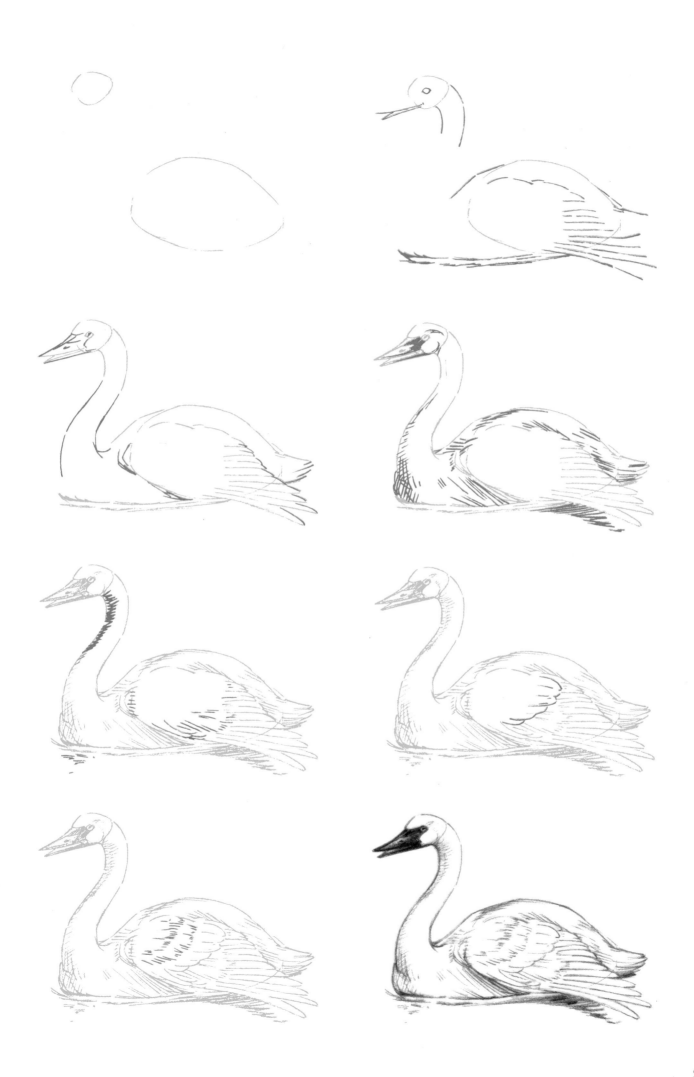

Swan

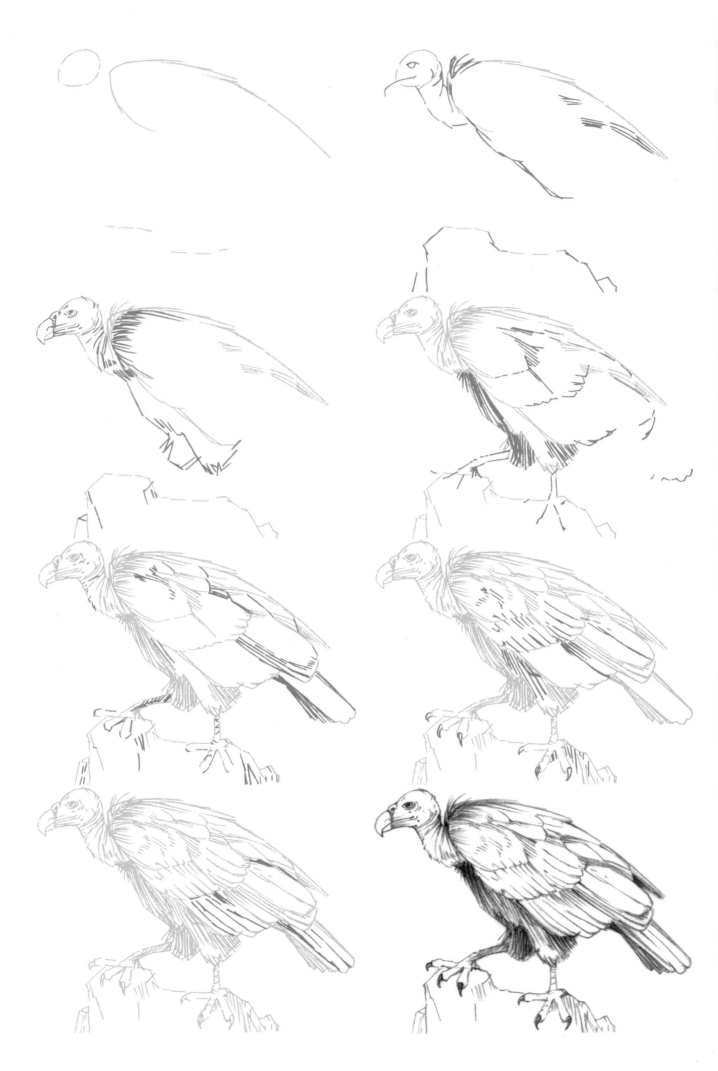

Vulture